F.V.

WITHDRAWN

St. Louis Community College

Forest Park
Florissant Valley
Meramec

Instructional Resources
St. Louis, Missouri

THE APERTURE HISTORY OF PHOTOGRAPHY SERIES

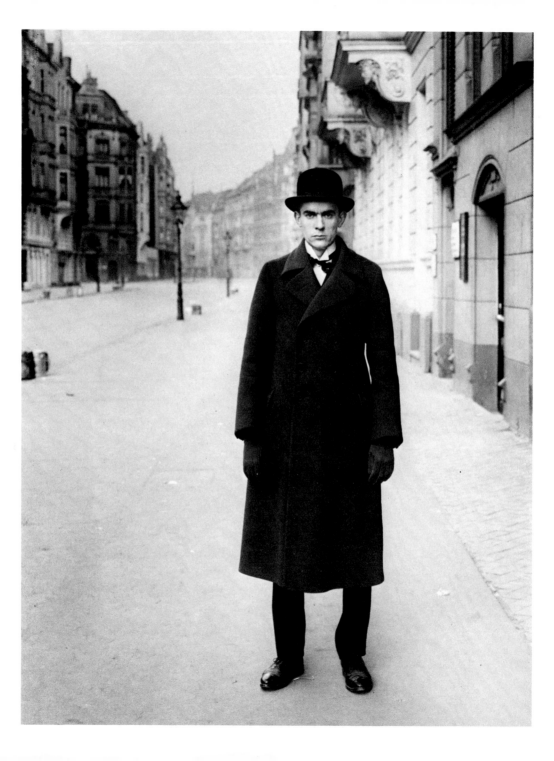

August Sander

APERTURE

The History of Photography series is produced by Aperture, Inc., under the artistic direction of Robert Delpire. *August Sander* is the seventh book of the series.

Aperture, Inc., publishes a periodical, portfolios and books to communicate with serious photographers and creative people everywhere. A complete catalogue will be mailed upon request. Address: Elm Street, Millerton, New York 12546.

Library of Congress Catalogue Card No.: 77-70069

ISBN: 0-89381-007-X

Manufactured in the United States of America

10 9 8 7 6 5 4 3 2 1

The long lines of Germans waiting to be photographed by August Sander in Cologne were not his usual eager patrons wanting portraits for the mantel. The year was 1918 and these Germans, recently defeated in World War I, needed pictures for the identification cards required by the victorious occupying forces. Although Sander toiled far into the night, he could not keep up with the demand until he hit upon an idea that was characteristically practical. He arranged his patrons in group portraits, which he then cut up into individual pictures. His work speeded up and he was able to satisfy his customers while supplying quality photographs.

The story illustrates much about Sander as both sensible studio photographer and artist. What he did in Cologne during those dark days following Germany's defeat, he later accomplished for the entire nation. The portraits that he created during his life were nothing less than a group portrait of an entire people. In the direct, unpretentious manner of a former miner, Sander recorded his countrymen during that tumultuous era between world wars. And

he did his work in such a traditional fashion that his originality and insights are all the more remarkable. Sander encouraged his sitters to face the camera confidently against almost any handy backdrop. Reassured by their familiar surroundings and the comforting presence of the undemanding photographer, the subjects presented to the camera the personality and attitude of their choosing. Incredibly, these consciously public faces invariably reveal—and betray—the private person. Sander's uncanny eye catches the individuality of the sitter as it breaks through the façade of the setting.

A paradoxical blend of romantic philosopher, meticulous workman and driven artist, Sander drew inspiration from the poetry of Goethe: "Is it not in the heart that the core of natural man resides?" Taking this rhetorical question as an eternal truth, Sander pursued his art with a Teutonic thoroughness. He scoured the country for faces to record, and even his darkroom was laid out so that every bottle and tray had its proper place to lessen the chance of accidents or mistakes. And Sander's vision was

heroic. His group portrait of his fellow Germans was projected as a collection of 500 to 600 photographs gathered under the imposing title "Man of the 20th Century." Although his actual production of portraits fell far short of his goal, this was due not to Sander's failure of spirit but to the crushing presence of Hitler's dictatorial state.

An untutored man who received only a grammar school education, Sander attacked life head-on. Although he was the shortest son in a family of nine children, his energy and strength matched with occasional outbursts of temper made him a volatile spirit. Once, when an obnoxious patron demanded at a public assembly that Sander take his portrait on the spot, the photographer grabbed him by the scruff of the neck and seat of the pants and rushed him from the premises. But these physical outbursts were rare. The quality that endeared Sander to those of his age was his honesty—the one word that cloaks his life and work. His occasional explosions and strong opinions never colored his attitude toward his subjects. "I never made a person look bad," he told his grandson, Gerd, a photographer and curator. "They do that themselves. The portrait is your mirror. It's you."

Sander was born in 1876 in the farming and mining country of Herdorf on the Seig River just east of Cologne. His father, a mine carpenter with a flair for drawing, amused his brood of children by sketching the family cats as they lounged in the warmth of the stove. It was from his father that Sander learned his skill with a pencil. Even though the parents dreamed of better things for their sons, Sander was apprenticed to the mines when still a youth. But his life changed irrevocably one day when he was chosen at random by the mine foreman to serve as a guide to a photographer making landscape studies. With his cumbersome 30 x 40 cm camera perched on its tripod atop a nearby hill, the photographer invited Sander to view the countryside through the lens. Sander's most vivid recollection of his first look at the world through a camera was one of motion—ironic for the future master of still photography. "Everything moved, even the clouds in the sky," he recalled. Sander never forgot the importance of motion in composition. As an older man, when he took Gerd on an expedition to photograph landscapes, he would set up the camera, then wait for the clouds to move into the proper position. Only then would he snap his portrait of nature.

Sander's family indulged his desire to learn photography. A prosperous uncle staked him to the necessary equipment, including a camera with the smallest plates available at the time—13 x 18 cm. And Sander's father built a darkroom as an annex to the barn. While the cameras of that period, the 1890's, remained unwieldy, the invention of the dry plate process at least gave the photographer the privilege of taking photographs and then developing them later in the darkroom. Sander worked at his new-found diversion; even a stretch in the army did not stay his march toward becoming a photographer. Stationed in Trier, he got a spare-time job with a

local photographer who made portraits of the soldiers to send home from the garrison town.

After his return to civilian life, Sander toured the country as a commercial photographer and broadened his scope by learning architectural and industrial photography. As was common among photographers in those days, he studied drawing and painting for one year at the art academy in Dresden. At the start of the new century, however, he abandoned canvas and oils to become an assistant to a studio photographer in Linz, Austria. A year later, in 1902, he returned to Germany to marry Anna, whom he had met during his army duty in Trier—a marriage that would endure for half a century. On a visit home Sander discovered that even his own family held little understanding of the importance he attached to photography. One of his brothers had turned the darkroom into a washroom and casually destroyed all but a few of his early negatives.

Back in Linz with his bride, Sander prospered under the standard photographic style of the time. His commercial portraits were traditionally posed, then printed through the gum bichromate process, which lent hues that made the photographs seem more painterly. The most prized portrait led the customer to believe it was painted by an artist rather than taken by a camera. Already a master printer, Sander saw no reason to deviate from the style that won him a state medal in competition and earned him enough money to buy out his boss.

Although he seemed to be succeeding financially, his life was complicated by an ambivalence toward money. He sought material comforts for his growing family, yet his investments were seldom shrewd. As his son Gunther wrote: "Money gave him pleasure only after he had spent it." Three passions emptied his pocketbook—antiques, paintings and books. While these possessions were admirable in themselves, their purchase contributed to the photographer's sorry economic state. When a polio epidemic spread throughout Austria in 1910 and his eldest son, Erich, was infected, Sander left Linz in debt and moved his family to Cologne, where he established another commercial studio.

Now in his mid-thirties, he embarked on the project that would elevate him to the first rank of portraitists. Seeking photographs that revealed more than subjects sitting in his studio, the photographer mounted a bicycle and rode into the countryside of Westerwald to make studies of the local farmers and tradesmen—the start of "Man of the 20th Century." It appears that he knew what he wanted from the outset. Since his project was conceived as a genealogy of a people—a chart of humanity—he sought archetypes as subjects. "The physical types in the chart were selected in a restricted area of the Westerwald," he wrote. "These people, whose way of life I had known from my youth, appealed to me because of their closeness to nature. . . . Thus the beginning was made and all the types discovered were classified under archetype, with all the characteristic common human qualities noted."

Sander approached his first trip to Westerwald with some anxiety. How would the peasants, habitually suspicious of outlanders, greet this city man riding a bicycle and lugging a camera? He need not have worried. Despite his urban successes, he remained a local man at heart. These were the people he grew up among; he spoke their language and was in sympathy with their spirit. Since he believed that the truthfulness of a portrait depended in large part on the rapport between subject and photographer, his photographs were his most eloquent acts of empathy.

His work was interrupted by World War I, when, as a reservist, he was called back into the army. After the war, his studio was inundated with calls for identification portraits. But when his business resumed its normal pace, Sander fell under the influence of modern art and its intellectual, vocal practitioners who became his friends in Cologne. Always partial to artists, it was through discussions among them that he understood the importance of his project and was encouraged to continue. He developed a close personal comradeship with Franz Wilhelm Seiwert, a painter and ebullient proponent of the new art styles.

The Sander-Seiwert dialogues were animated and contentious as befit two artists of strong views. But under the stimulus of these discussions about art, Sander experimented with new methods of printing. Using a glossy-surfaced printing paper designed for technical photographs, he made an enlargement of a Westerwaldian peasant's portrait. On the slick paper, every detail leaped from the print. Nothing was blurred for romantic effect. Gone was the rosewater hue of the gum bichromate process with its affected tinting to create an artificial mood. Sander and Seiwert put aside their intellectual differences to share a sincere enthusiasm for this new clarity. The photographer's joy was tempered only by the realization that his clients would continue to demand the more flattering gum prints.

To satisfy the artistic demon raging within him, however, Sander began to print what were to become his most famous photographs from the "Man of the 20th Century" project. These prints signaled the purity that remain his hallmark. Inspired, Sander continued "Man of the 20th Century" by searching out people in every walk of life. All of Germany passed before his lens, as no profession, class or type could escape his cool, unjudgmental eye. As always, he searched for the archetype, the person who fulfilled a role in society yet remained an individual human being. To indicate the universal scope of his project, he never listed the name of a subject; the only identification is the occupation or activity of the person.

Sander became the chronicler of the Weimar Republic, that star-crossed epoch between the fall of Kaiser Wilhelm and the rise of Adolf Hitler. Germany in those days simmered with conflicting passions, a land that alternated between dreams and nightmares, hope and decadence. The heady air of nascent political free-

dom slowly grew heavy with the yearnings of a restless population for a return to the security of absolutism. Sander watched calmly, his camera dispassionately recording the German people with unflinching clarity.

"Man of the 20th Century" was Sander's major work. Every portrait he made was to be included in a crowning publication—or so he planned. As a preview of his monumental effort, and to stimulate subscription sales for its ultimate publication, some sixty photographs by Sander were published in 1929 under the title *Faces of Time*. Although sales were disappointing, the volume stirred interest among intellectuals as a work of stature and importance. In the introduction, novelist Alfred Döblin wrote, "Seen from a certain distance, the differences [between the subjects] vanish, the individual ceases to exist, and the universality is all that remains."

For all their hopes and promise, Sander's work and the Weimar Republic both came to grief in the 1930's. Sander's son Erich, a socialist who actively resisted the Nazis, was imprisoned and eventually died in a concentration camp in 1944. Sander's book joined other works of art that were driven from the marketplace by the Gestapo, its printing plates destroyed. The photographer's archives were searched. The Nazi excuse for this abomination was the politics of Sander's son. But it is likely that the real reason the Nazis persecuted Sander lay in his ability to depict the truth about his fellow Germans. He did not glorify the master race, nor even hold up the Nazis to ridicule. He simply showed the Germans—including the Nazis—as they were. This was not only a violation of the totalitarian state's propaganda; these truthful pictures were condemnation in themselves.

Seeking refuge from the storms of war, Sander retreated to Westerwald; he salvaged his archives by storing them in the country. After the war, he attempted to pick up the threads of his work but found them frayed or broken. Slowly, recognition of his artistic achievement came his way in the form of state and international honors. His "Man of the 20th Century" was never published in one comprehensive book, but volumes of his work did appear. In 1964, at the age of eighty-eight, Sander succumbed to a stroke.

An appreciation of Sander's genius is apparent from even a casual glance at his photographs. Armed with his camera and insights, he went out among his people and brought back images of their souls. As we search the faces from those lost decades, we are startled to see reflections of ourselves.

John von Hartz

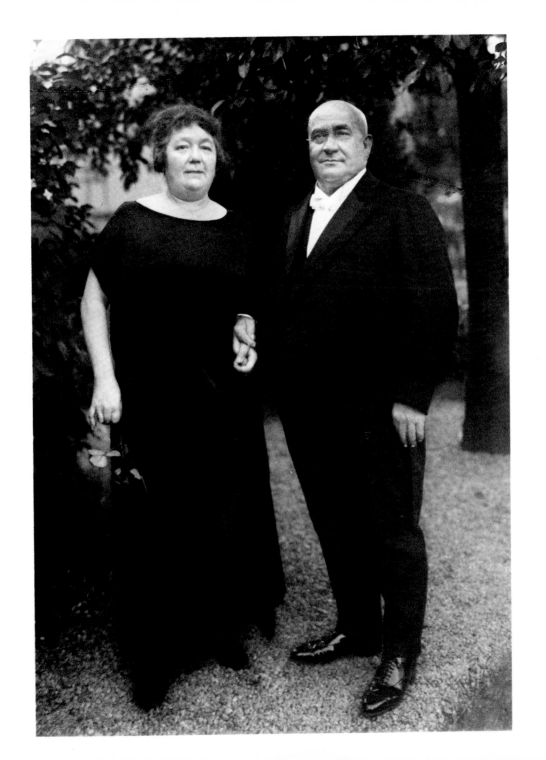

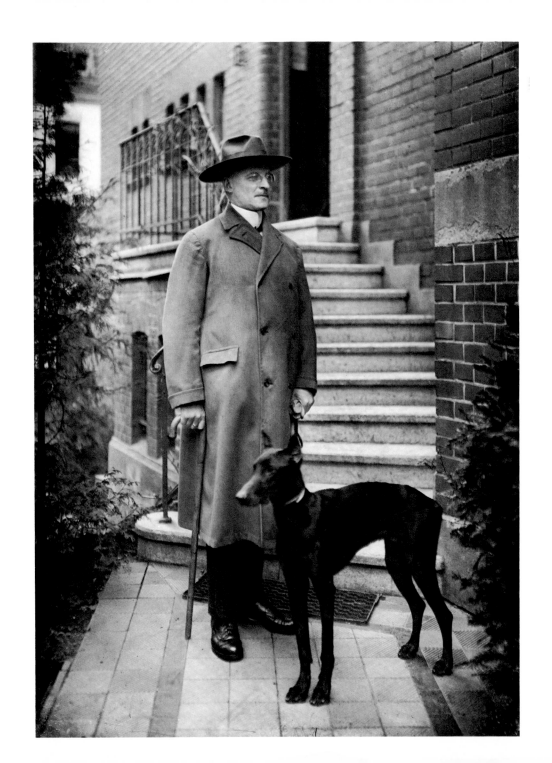

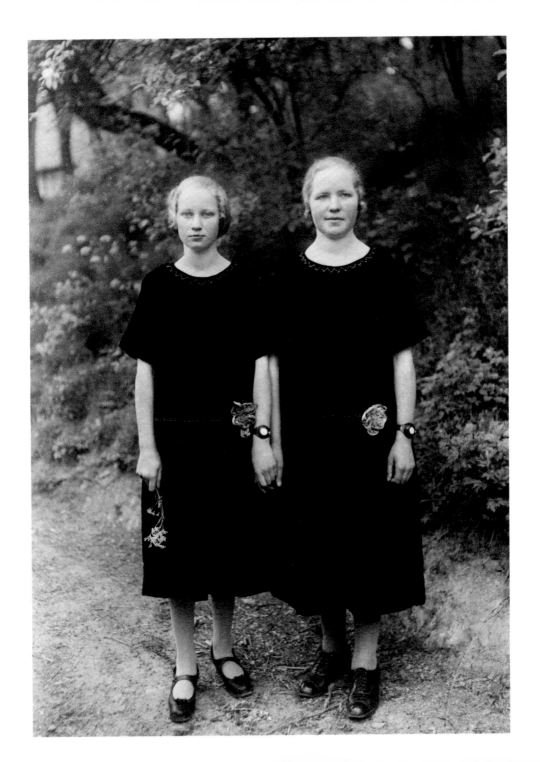

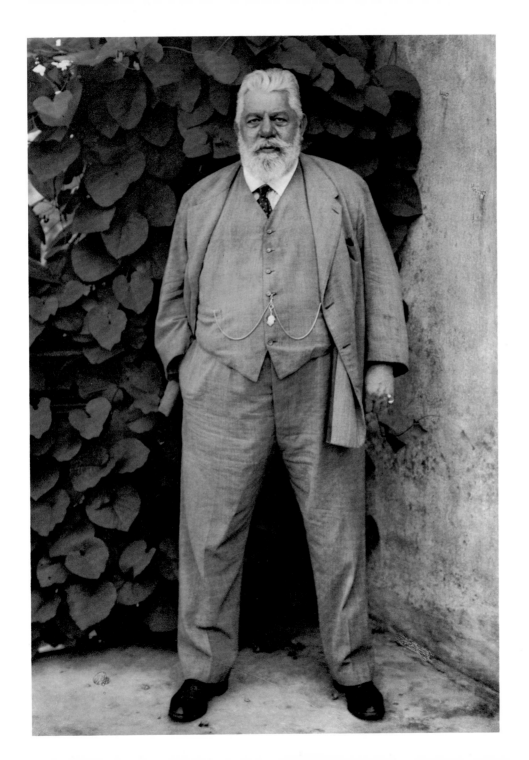

17

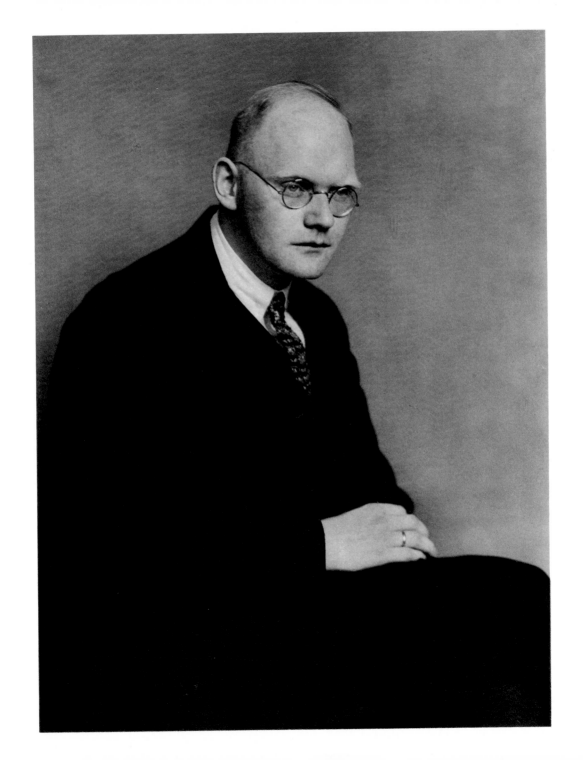

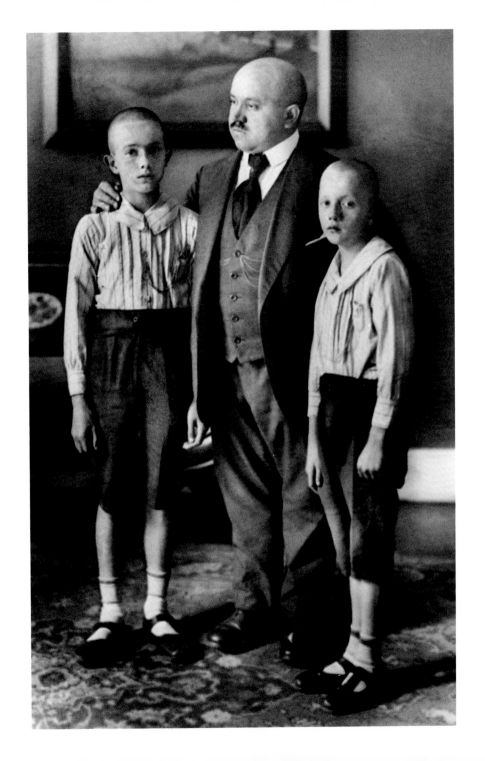

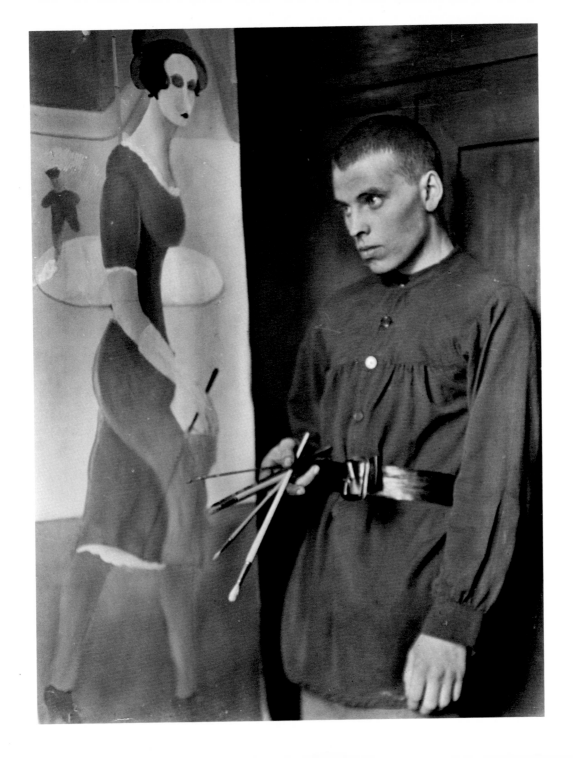

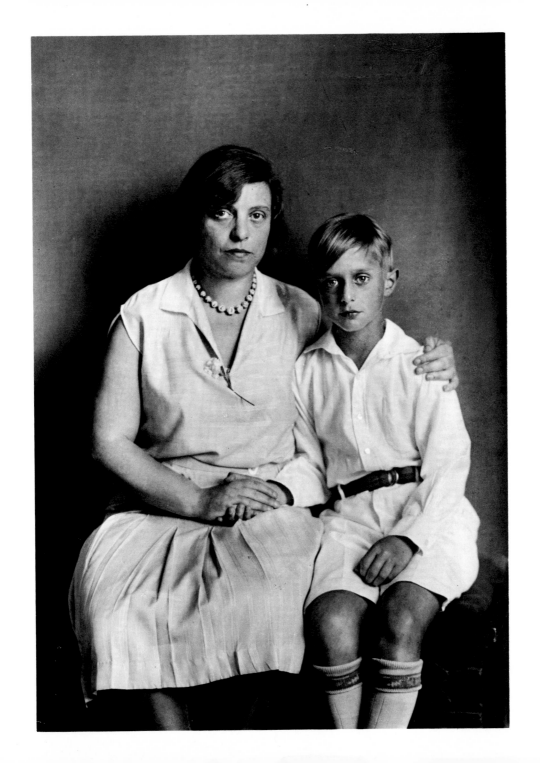

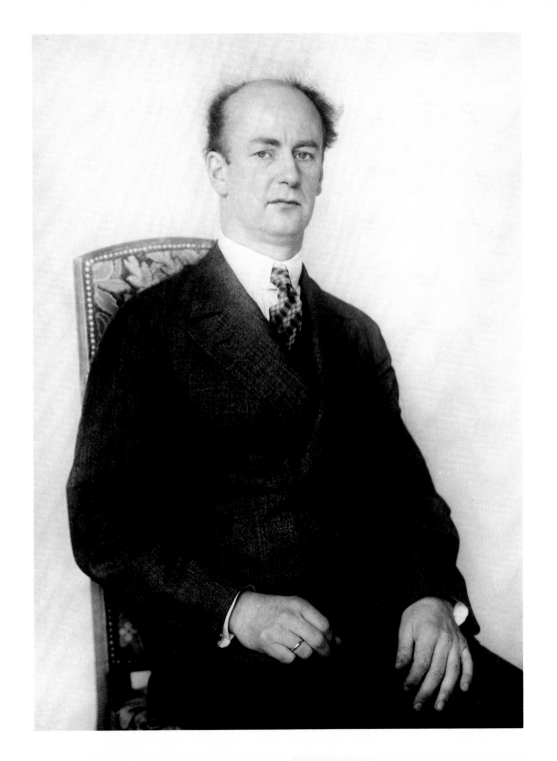

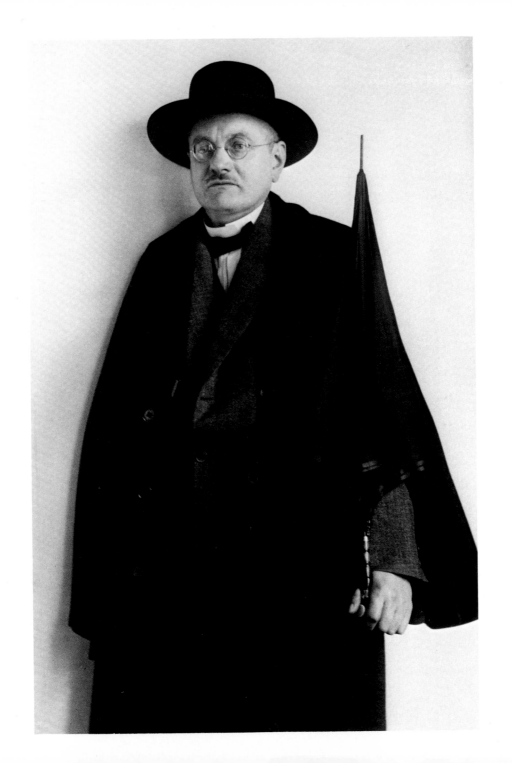

29

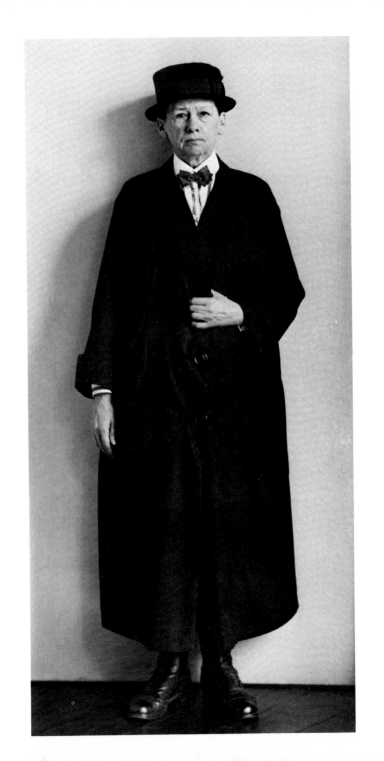

31

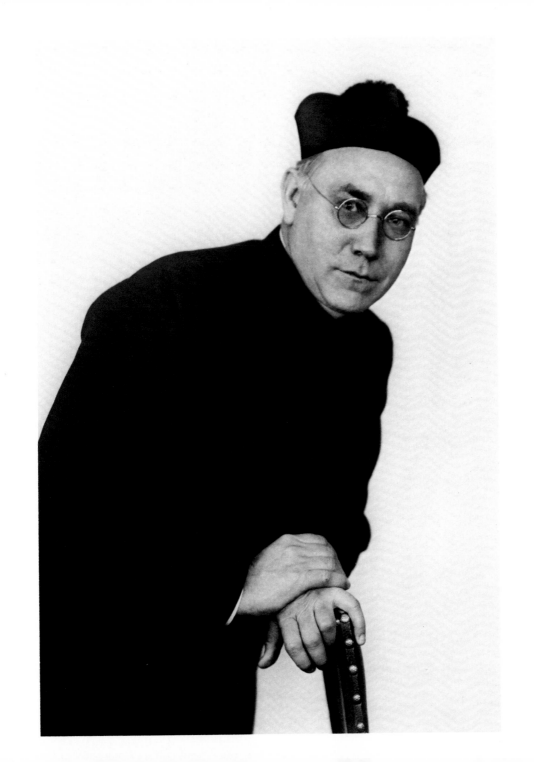

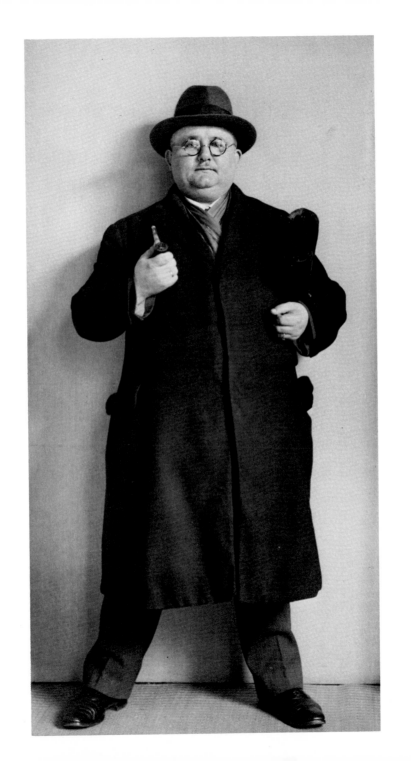

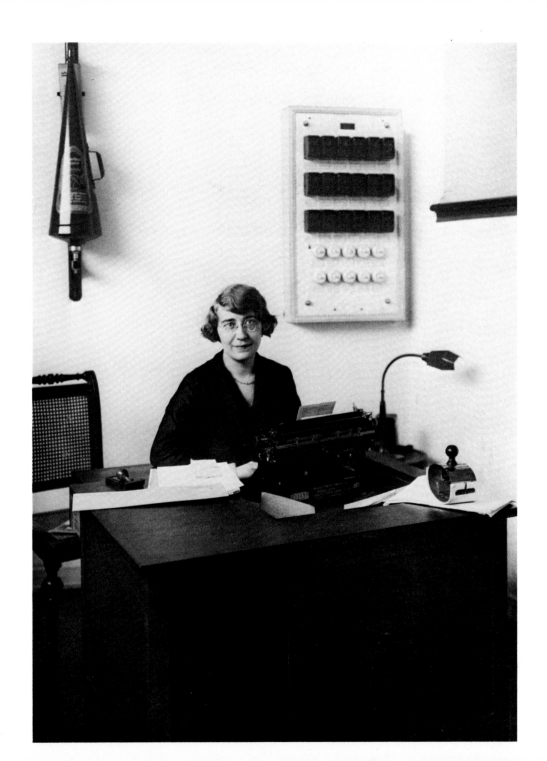

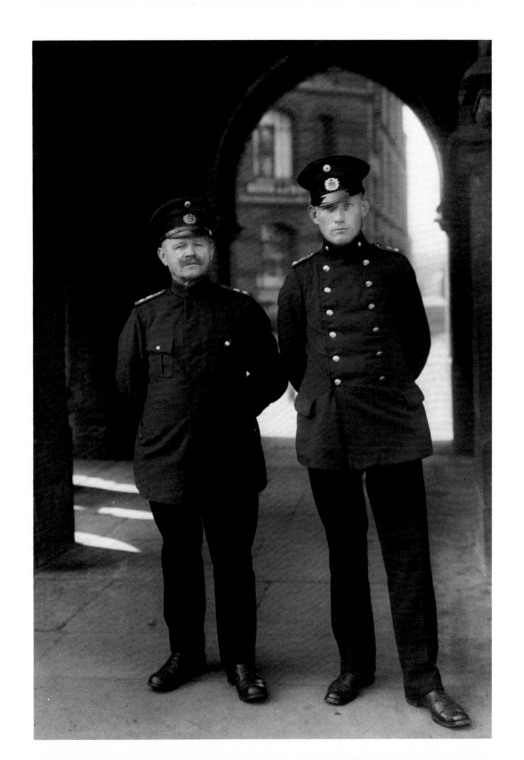

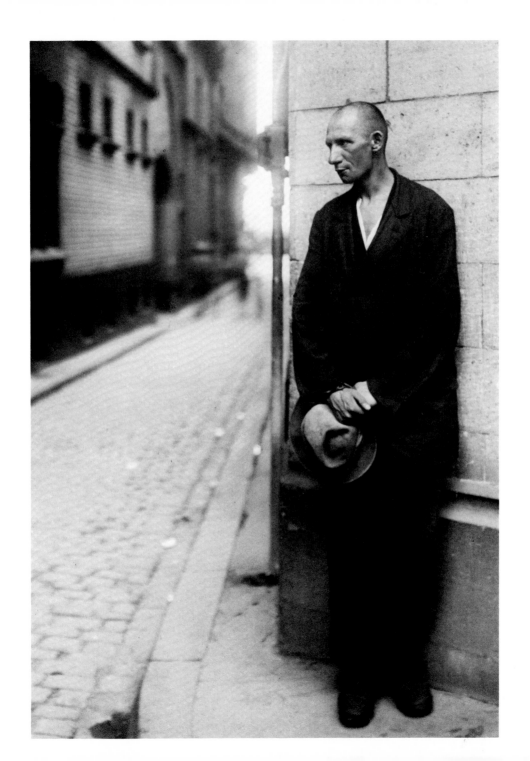

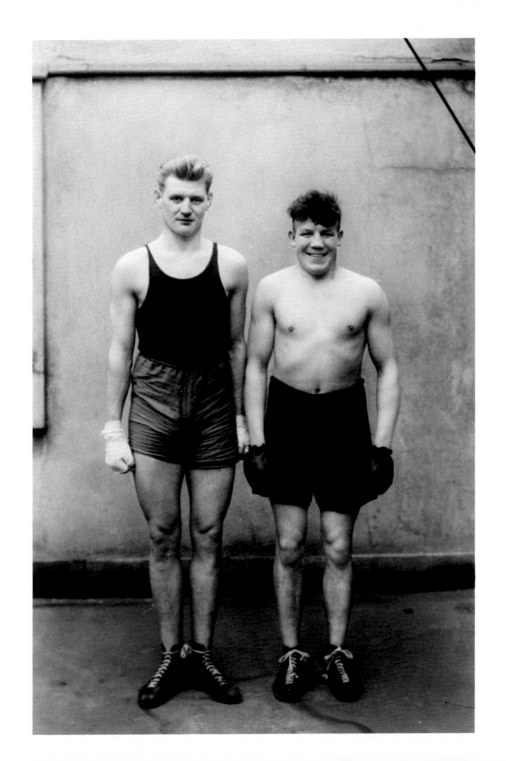

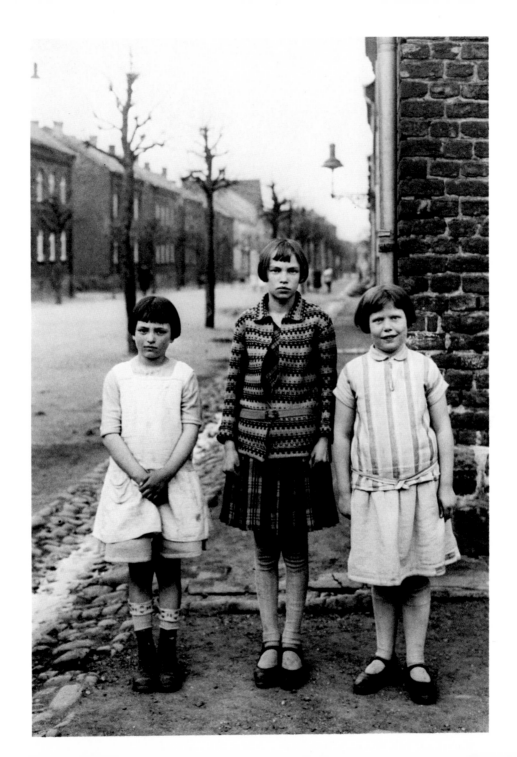

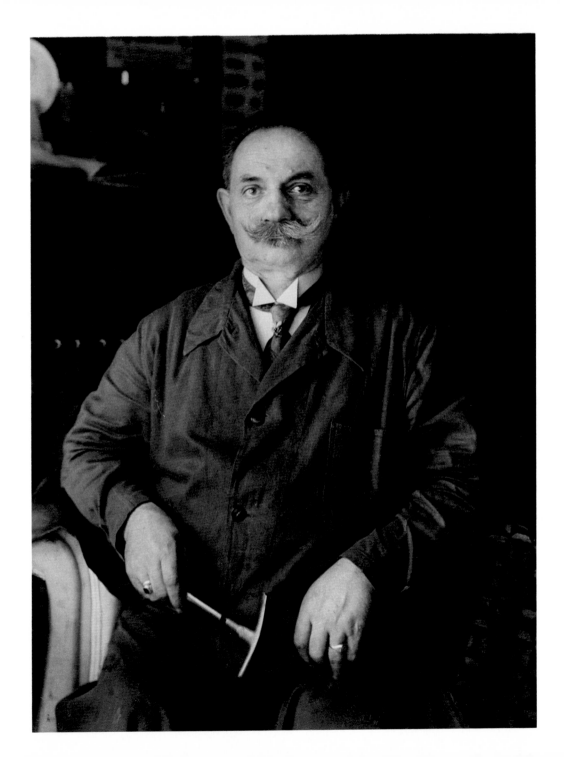

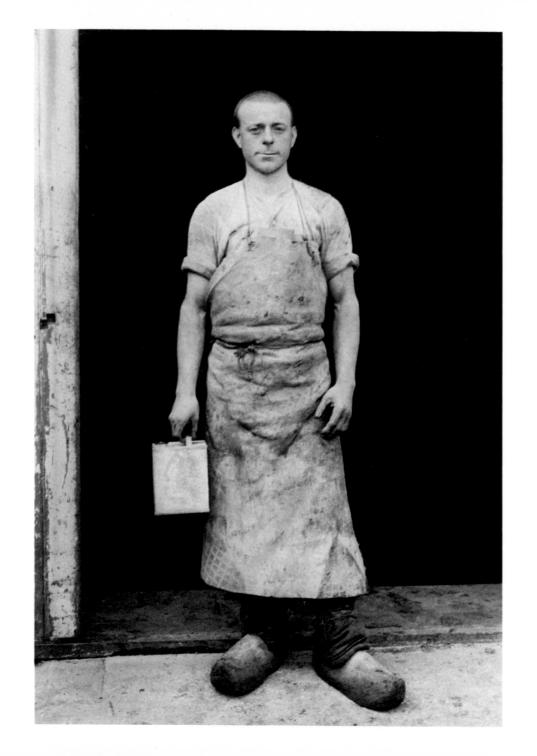

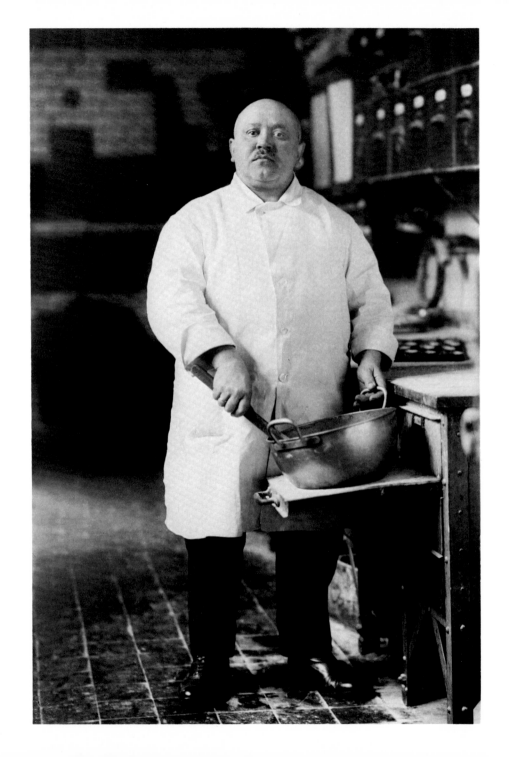

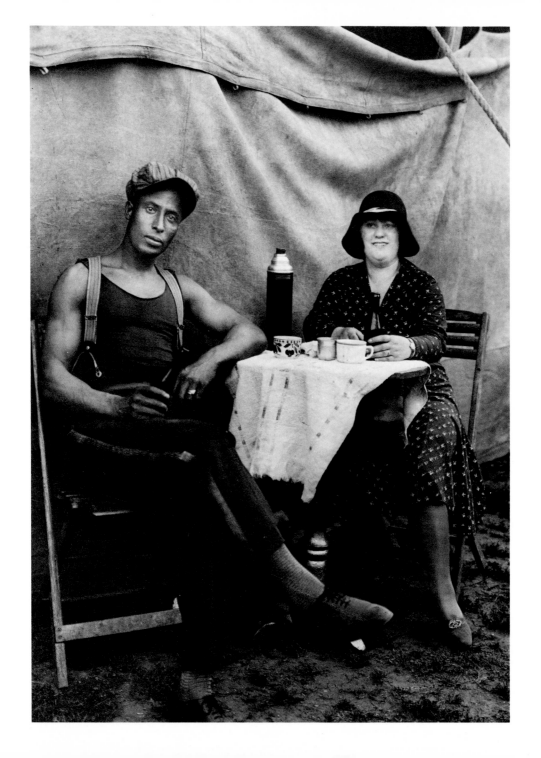

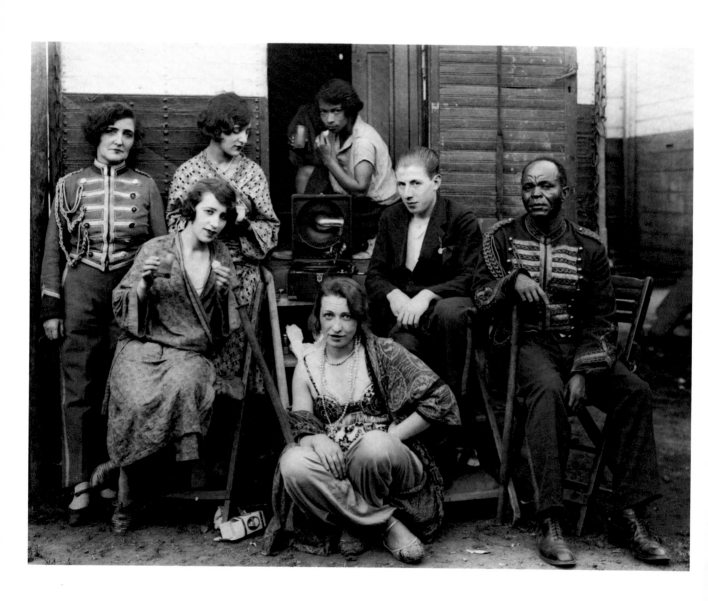

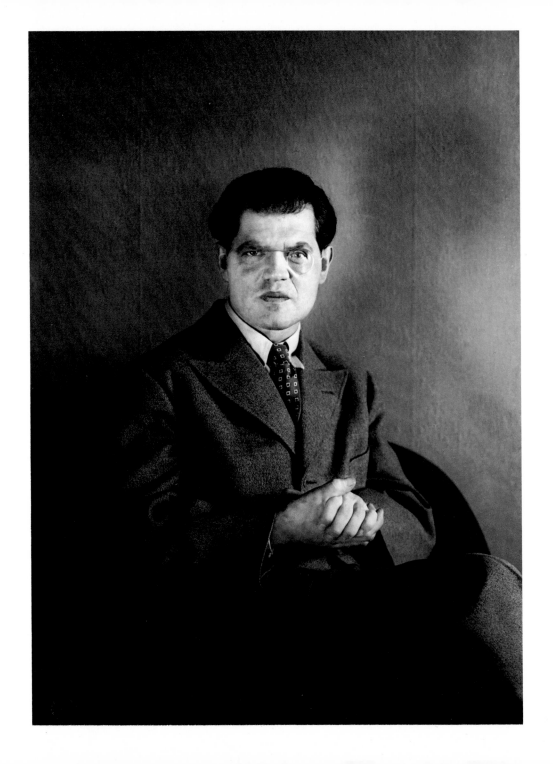

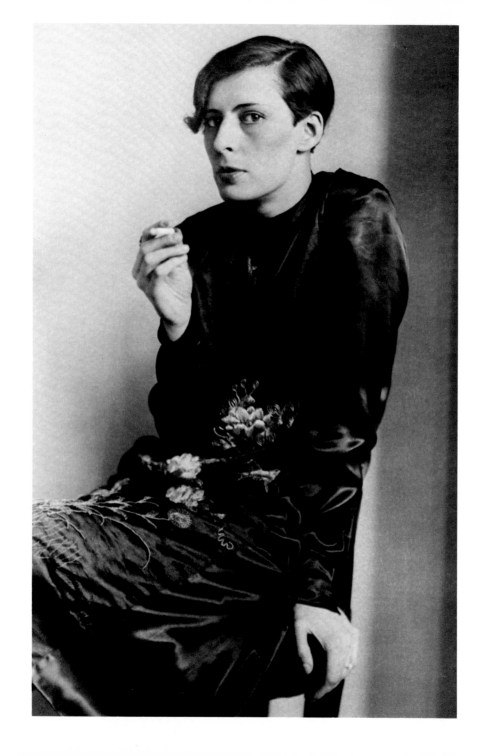

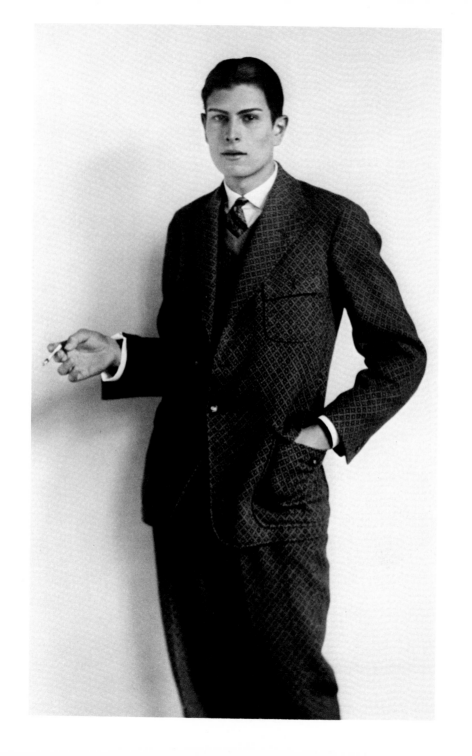

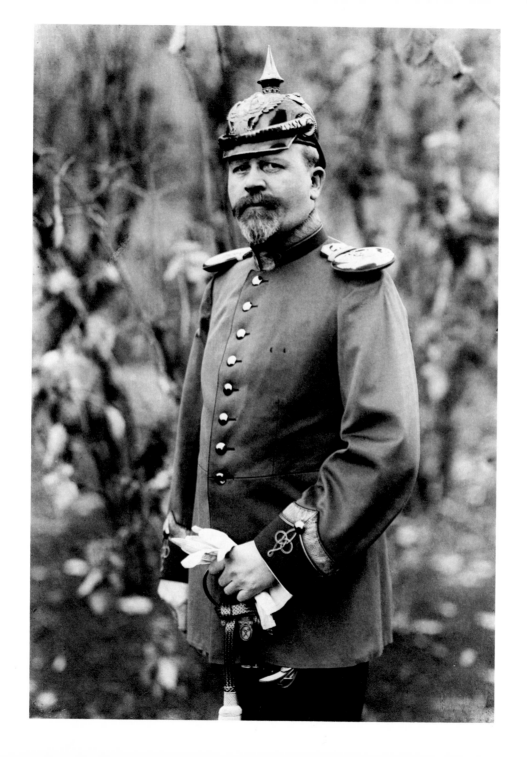

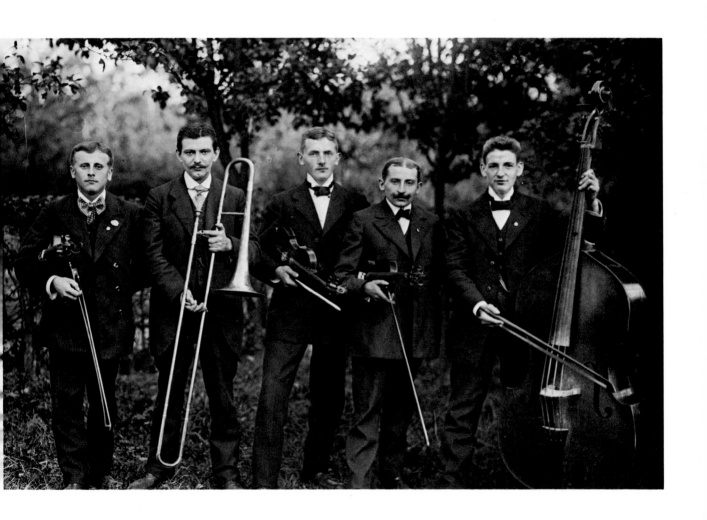

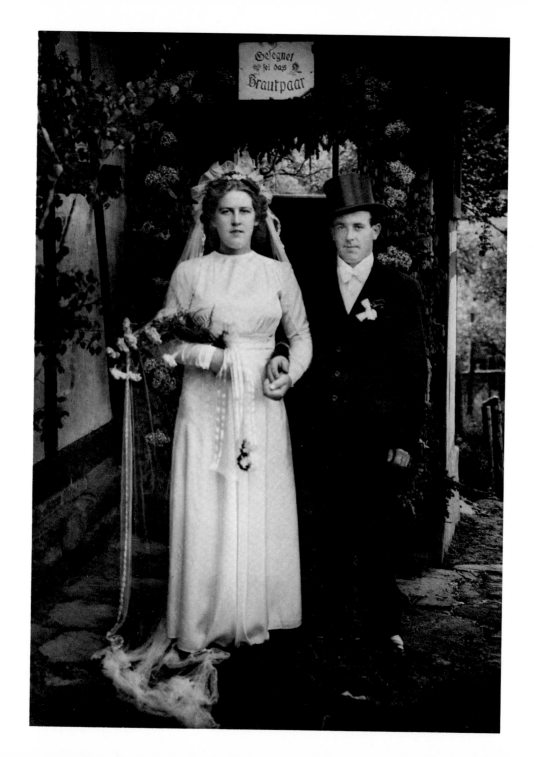

67

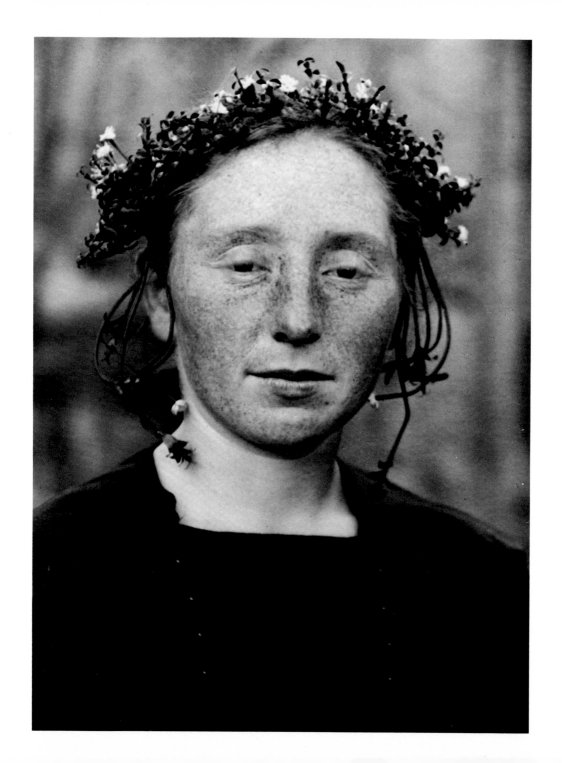

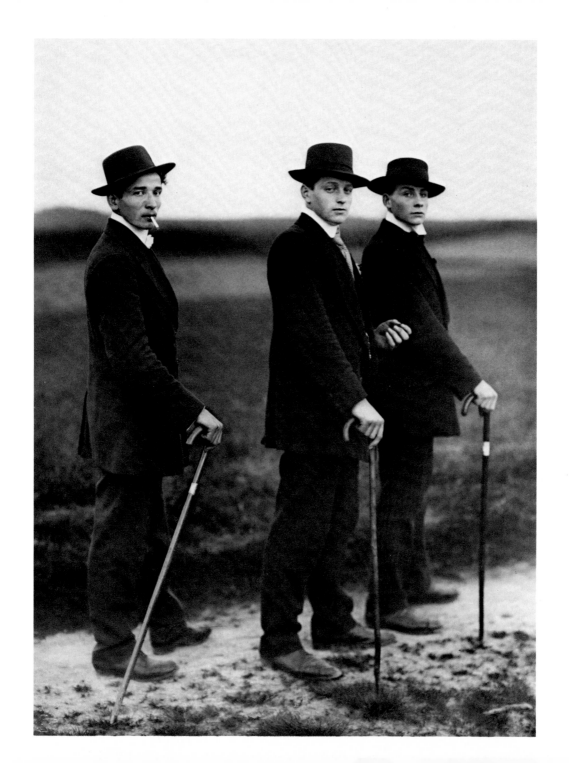

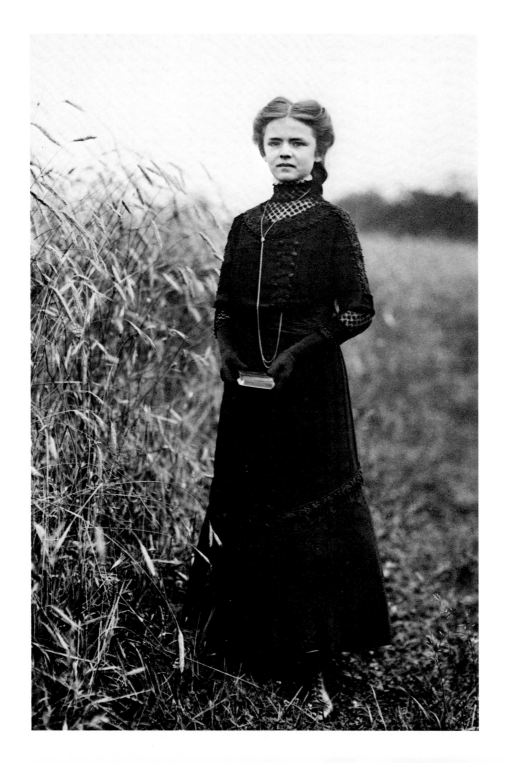

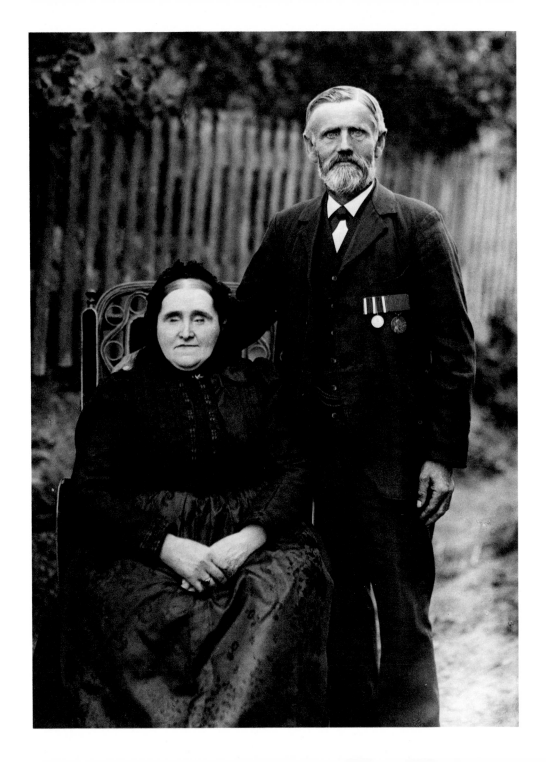

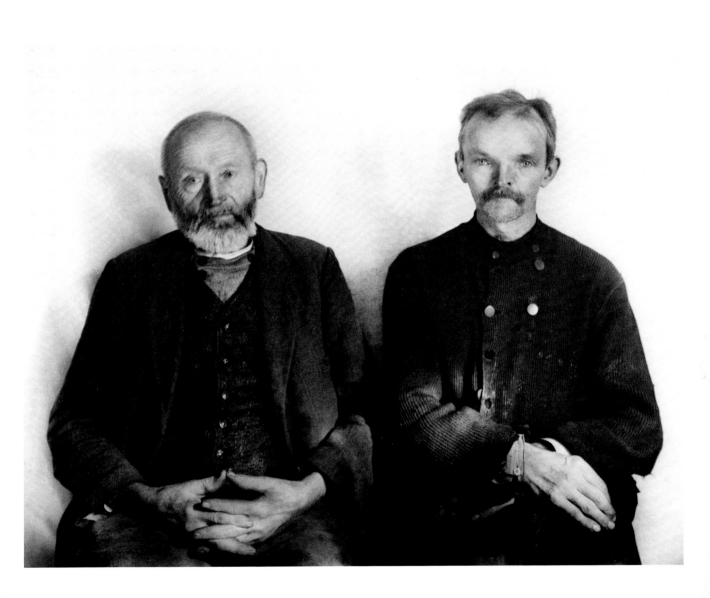

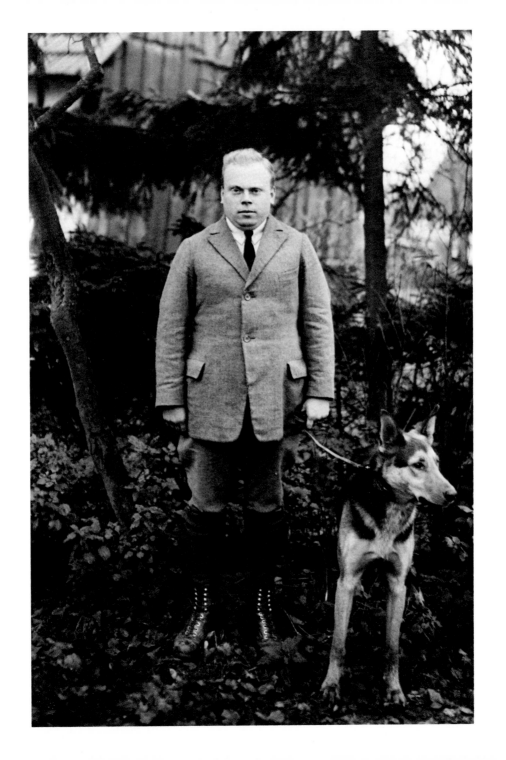

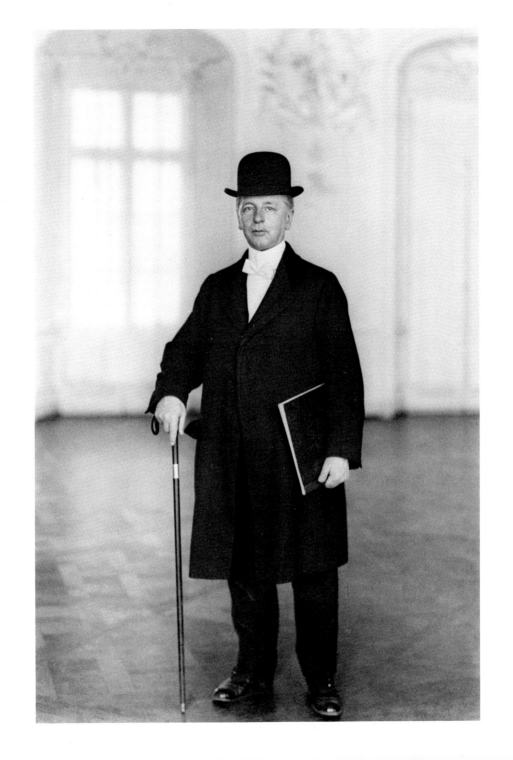

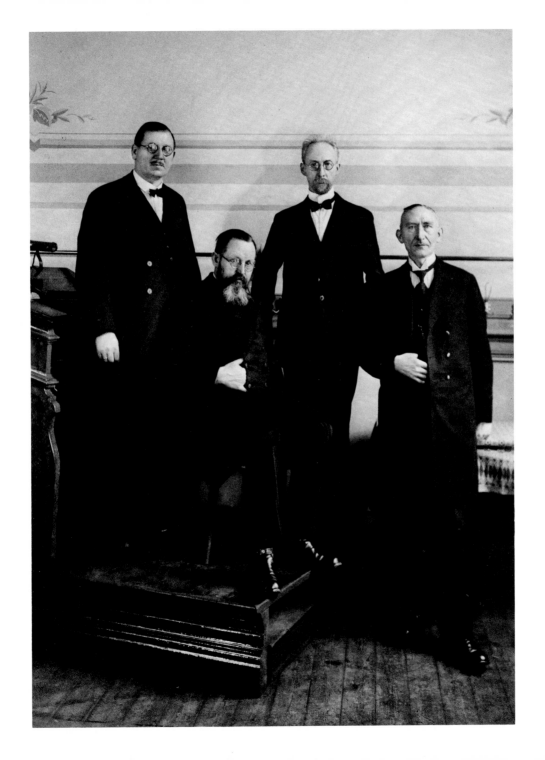

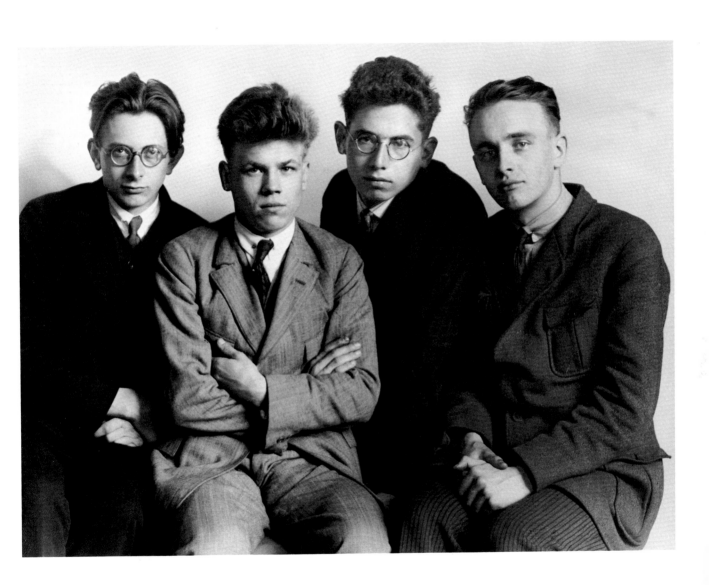

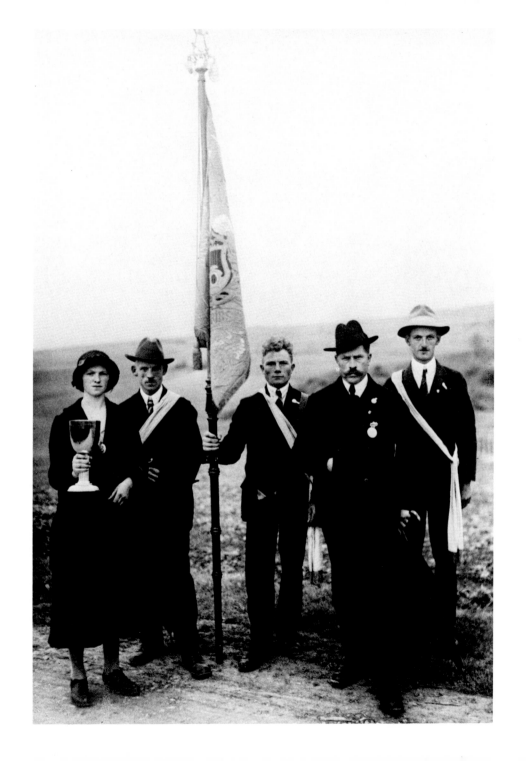

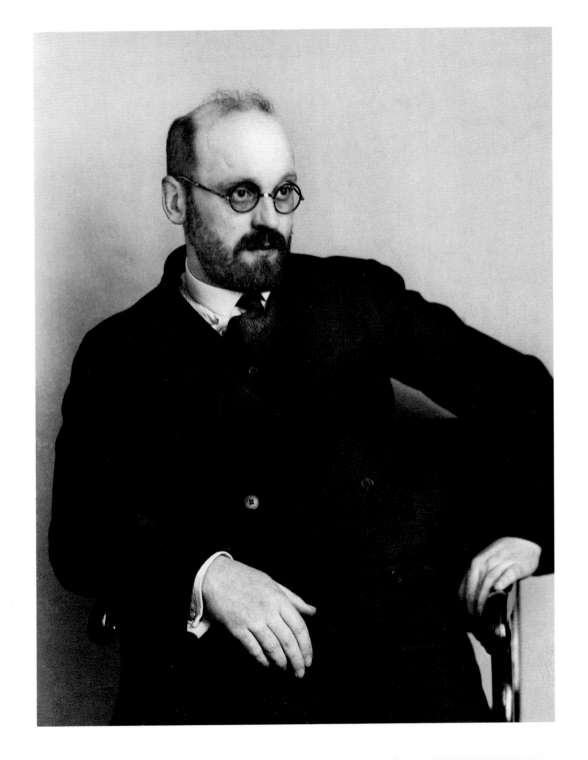

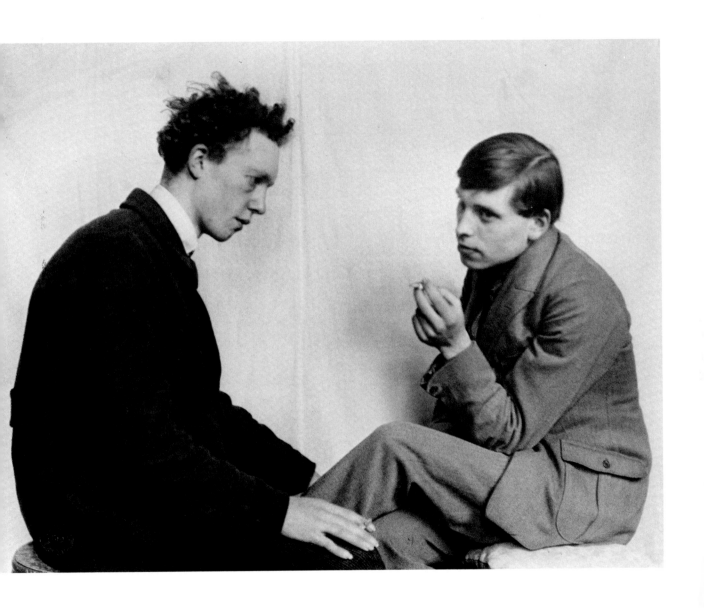

PHOTOGRAPHS

Front Cover: Bicyclists, Westerwald, 1922
Frontispiece: Painter, Cologne, 1927

11. Landowner, Cologne, 1924
13. Notary, Cologne, 1924
15. Peasant Girls, Westerwald, 1928
17. Pharmacist, Linz, 1931
19. Writer and Editor, Cologne, 1928
21. Widower with Sons, Cologne, 1929
23. Painter G.B., Cologne, 1924
25. Wife of painter M.E. with son, Cologne, 1926
27. Industrialist, Weiden, near Cologne, 1929
29. Representative (Democratic Party), Cologne, 1928
31. Real Estate Broker, Cologne, 1928
33. Priest, Cologne, 1926
35. Repossessor, Cologne, 1931
37. Typist, Cologne, 1928
39. Customs Officials, Nuremberg, 1928
41. Unemployed, Cologne, 1928
43. Boxers, Cologne, 1928
45. City Children, Cologne, 1932
47. Paperhanger, Berlin, 1929
49. Varnisher, Cologne, 1932
51. Pastry Chef, Cologne, 1928
53. Circus People, Düren, 1930
55. Circus People, Düren, 1930
57. Inventor, Berlin, 1928
59. Secretary, Cologne, 1931
61. High School Student, Cologne, 1926
63. Officer, World War I, Cologne, 1914
65. Village Band, Westerwald, 1913
67. Peasant Couple, Westerwald, 1932
69. Peasant Bride, Westerwald, 1914
71. Peasants Going to a Dance, Westerwald, 1914
73. Confirmation Candidate, Westerwald, 1911
75. Farm Couple, Westerwald, 1914
77. Peasants, Westerwald, 1930
79. Village Schoolteacher, Westerwald, 1914
81. Pianist, Cologne, 1928
83. Protestant Missionaries, Cologne, 1931
85. Working Students, Cologne, 1926
87. Prizewinners, Westerwald, 1927
89. Writer, Cologne, 1928
91. Bohemians, Cologne, 1924

BRIEF CHRONOLOGY

1876. August Sander born in Herdorf Sieg, Germany.
1892. Buys first camera.
1896–98. Serves in German army at Trier. Begins training in photography.

1902. Marries Anna Seitenmacher in Trier.
1903. Son Erich is born.
1904. Buys studio in Linz, Austria, and works in color photography. Exhibits in Linz, Wels/Donau, Halle/Saale, Cologne, etc. Wins Gold Medal and

Cross of Honor for arts and sciences at international exhibition in Paris.

1907. Son Gunther is born.

1910. Moves with family to Cologne. Begins project on study of faces.

1911. Daughter Sigrid is born.

1914–18. Serves in German army in World War I.

1919–44. Opens studio in Cologne. Does commercial portraits, advertising and industrial photography. Photographs people of all classes and ranks, and works persistently on body of work "Menschen des 20 Jahrhunderts" ("Man of the 20th Century"). Associates with "Kölner Progressive" group. Painter Franz Seiwert becomes influential friend. In 1927 works with folk writer Ludwig Mathar for three months in Sardinia.

1927. First exhibition of 60 photographs at Kölnischer Kunstverein.

1929. *Antlitz der Zeit* (*Faces of Time*) with 60 photographs and a preface by Alfred Döblin published by Transmare Verlag, Munich.

1934. Son Erich, member of SAP (Socialist Workers Party), imprisoned by Nazis; dies in 1944. *Antlitz der Zeit* confiscated and plates destroyed. Begins to work mainly in landscape photography.

1944. Studio and apartment destroyed during bombing of Cologne. Negatives lost in fire shortly after war. Moves with Anna to Kuchhausen, small village in the Westerwald, 50 miles from Cologne. Continues to photograph.

1951. First exhibition at Photokina after war. City of Cologne buys work "Köln wie es war" ("Cologne as It Was").

1954. Edward Steichen, in preparing for exhibition "Family of Man," chooses 80 Sander photographs for collection of The Museum of Modern Art, New York.

1957. Wife Anna dies.

1958. Becomes honorary citizen of hometown, Herdorf/Sieg.

1959. Publication in Swiss magazine *du*.

1961. *Deutschenspiegel* published by Sigbert Mohn Verlag, Gütersloh. Receives Federal Order of Merit of Germany.

1964. Dies at age 88 in Cologne.

BOOKS BY AUGUST SANDER

Antlitz der Zeit (Faces of Time), text by Alfred Döblin. Munich/Berlin: Transmare Verlag, 1929.

Bergisches Land: German Land, German People, text by August Sander. Düsseldorf: Schwann, 1933.

Die Eifel: German Land, German People, text by August Sander. Düsseldorf: Schwann, 1933.

Die Mosel: German Land, German People, text by August Sander. Rothenfelde: Holzwarth-Verlag, 1934.

Das Siebengebirge: German Land, German People, text by August Sander. Rothenfelde: Holzwarth-Verlag, 1934.

Die Saar: German Land, German People, text by Joseph Witsch. Rothenfelde: Holzwarth-Verlag, 1934.

Deutschenspiegel (Man of the 20th Century), introduction by von Heinrich Lützeler. Gütersloh: Sigbert Mohn Verlag, 1962.

Men Without Masks, text by Golo Mann and Gunther Sander. New York: New York Graphic Society, 1972.

Rheinlandschaften (Landscapes at the Rhine River), text by Wolfgang Kemp. Munich: Schirmer Mosel Verlag, 1975.

Lectures by August Sander for West German Radio, Cologne, 1931: "From the Workshops of Alchemy to Precise Photography"; "Nature and Development of Photography from Past to Future"; "Photography at the Turn of the Century"; "Photography in Science and Technology"; "Photography—A Universal Language"; "Photography Today."

ARTICLES ABOUT AUGUST SANDER

Bourfeind, Dr. Paul, "On Man of the 20th Century." *Rheinische Blätter für Kulturpolitik,* January 1928, Cologne.

Eggebrecht, Axel, "A Photographic Book: Review of *Faces of Time." Die Literarische Welt,* No. 11, March 14, 1930, Berlin.

Panther, Peter, "On the Night Table." *Weltbühne,* March 25, 1930, Berlin.

Benjamin, Walter, "Small History of Photography." *Die Literarische Welt,* No. 40, October 2, 1931, Berlin.

Mathar, Ludwig, "Sardinia." *Kölner Statd-Anzeiger,* No. 453, September 7, 1933, Cologne.

"First Laughed At—Now Famous." *Rhein Zeitung,* May 6, 1958, Cologne.

du Magazine, No. 225, November 1959.

Szarkowski, John, "August Sander Portraits: A Selection of the Work of One of Germany's Greatest Photographers." *Infinity,* June 1963, p. 4.

Thornton, Gene, "A Great Portraitist Feared by the Nazis." *The New York Times,* September 28, 1975, Section II, p. 1.

Pommer, Richard, "August Sander and the Cologne Progressive." *Art in America,* Vol. 64, No. 1, January-February 1976, pp. 38–39.